Happy Father's Day...Happy Father's Day...Happy Father's Day...Happy Father's Day...Happy Father's Day...Happy Father's Day...Happy Father's Day...Happy Father's Day...

Written by: Melissa L. Bryant

I dedicate this book to my father George Bryant. I also dedicate this book to my belated father James Moore who I miss so much. I dedicate this book to my two sons Darrell & Vyshonn. You are all amazing fathers. I dedicate this book to my God-father Kim Ray. Thank you all for all the love and support. I also would like to dedicate this book to all the fathers in jail or prison. My heart goes out to you all. I know you're missing your child or children. But you all hang in there. God loves you! He cares and he hears your prayers, right now he's drying your tears away. Happy Father's Day! God bless you all and you better believe the best is yet to come. Fathers are incredibly special as well as mothers.

Today is your day fathers. We love you so much and don't forget that, to all the fathers around the world. Happy Father's Day!

Go fathers! It's your day. Happy Father's Day! Enjoy your day, fathers.

Fathers who's in jail or prison, Happy Father's Day! God bless you!

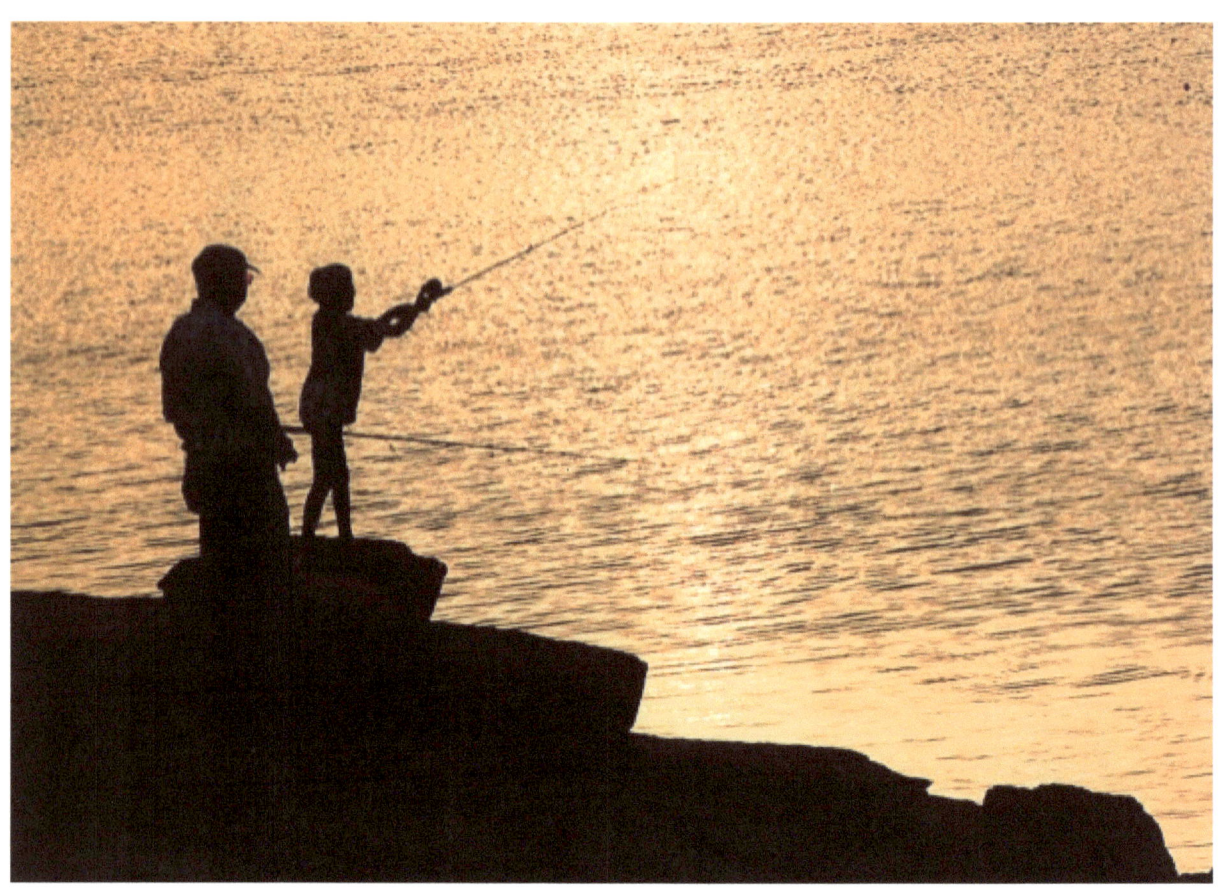

Dad, you have taught my boys how to fish. I am glad you're their grandfather and thank you for all you taught them. I love you so much. We are blessed to have you as a father and grandfather.

Lord to someone who meant so much to me. I really miss my belated dad James Moore so much. Dad, you left me with tears and precious memories too. If I could have one lifetime wish, a dream that would come true, I'd pray to God with all my heart you were still here. Dad, you taught me so much in life. I miss and love you so much. Dad, you will always be in my heart. Happy Father's Day!

My Daddy

My Daddy is a mountain

My Daddy is a sea

My Daddy smiles again and again

I love my Daddy

And I know he loves me

'cause my Daddy is a ray of lite

that warms a winters' eve

My daddy is very special to me

I could not live without my daddy

as he could not live without me.

Happy Father's Day!

Happy Father's Day! The fathers who have left us behind miss you so much. It's not the same without great fathers like you all.

The greatest gift I ever had come from God is my father. I love you, dad, so much. Happy Father's Day!

Fathers are the strength of the family, to bond us and hold us together. Happy Father's Day! We love you fathers.

My Heavenly Father, your lovingly repaired my broken spirit, helped me plot a new course, and set me free with wings to fly on my own once again. I love you father. My Heavenly Father who I love so much, Happy Father's Day!

Dedicated
And
Devoted

Pastor McComb, you gave me hope when I had none. Happy Father's Day! I love you and I really thank God for you. I have learned so much wisdom from you. I am glad that God has shine on you. Thank you for being real and letting God have his way in you. Even though I am not in Daleville, Alabama, I keep that word you taught me everywhere I go. God bless you and the best is yet to come.

Fathers, it's a special bond that will keep us close forever, no matter where we are or what we're doing. Happy Father's Day!

Fathers, we appreciated all you did for us. Fathers always make your child or children feel special.

Dad, when I had fallen, you helped me stand. I love you so much. Happy Father's Day!

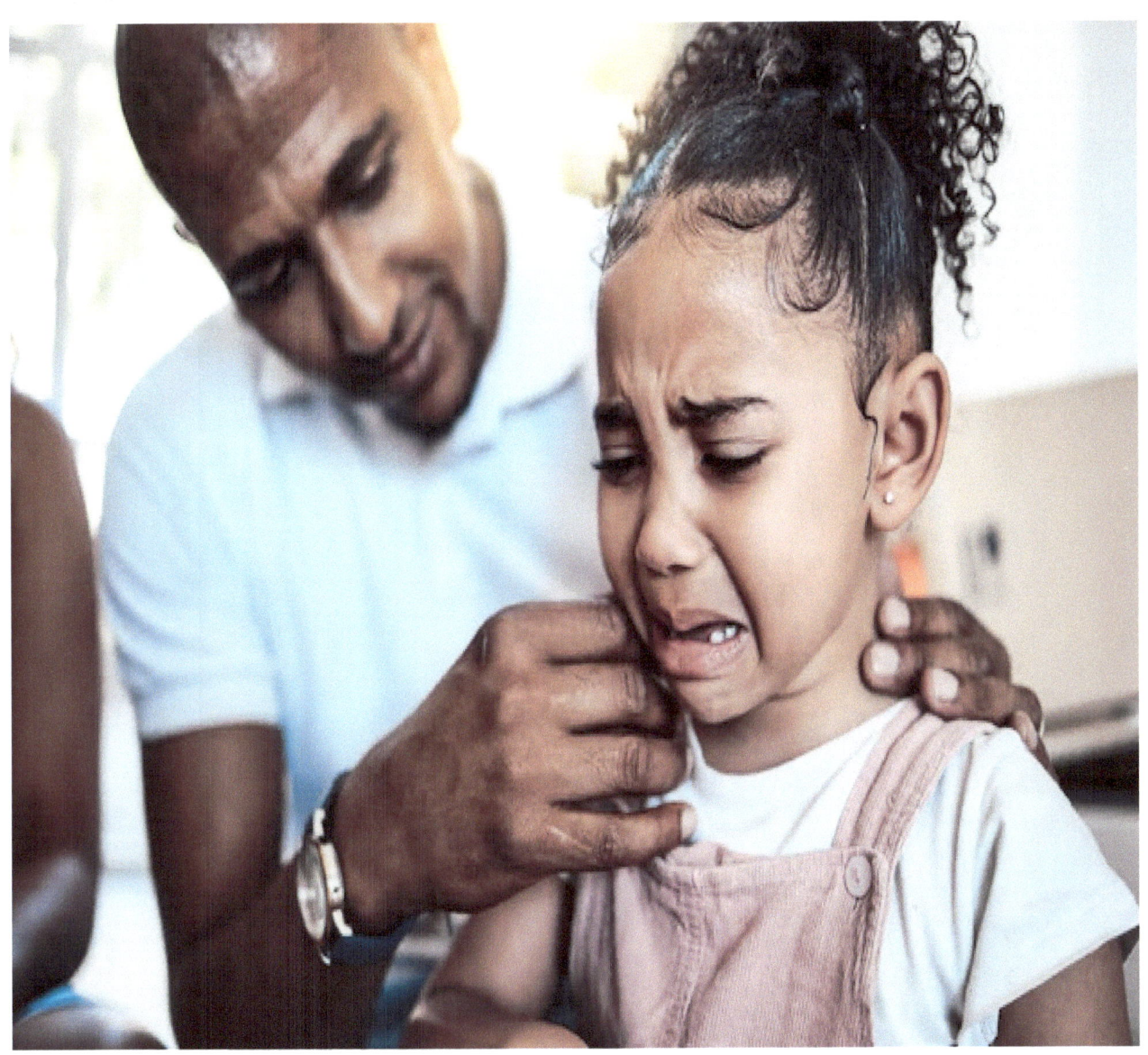

When I cried, you gently wiped the tears away from my face.

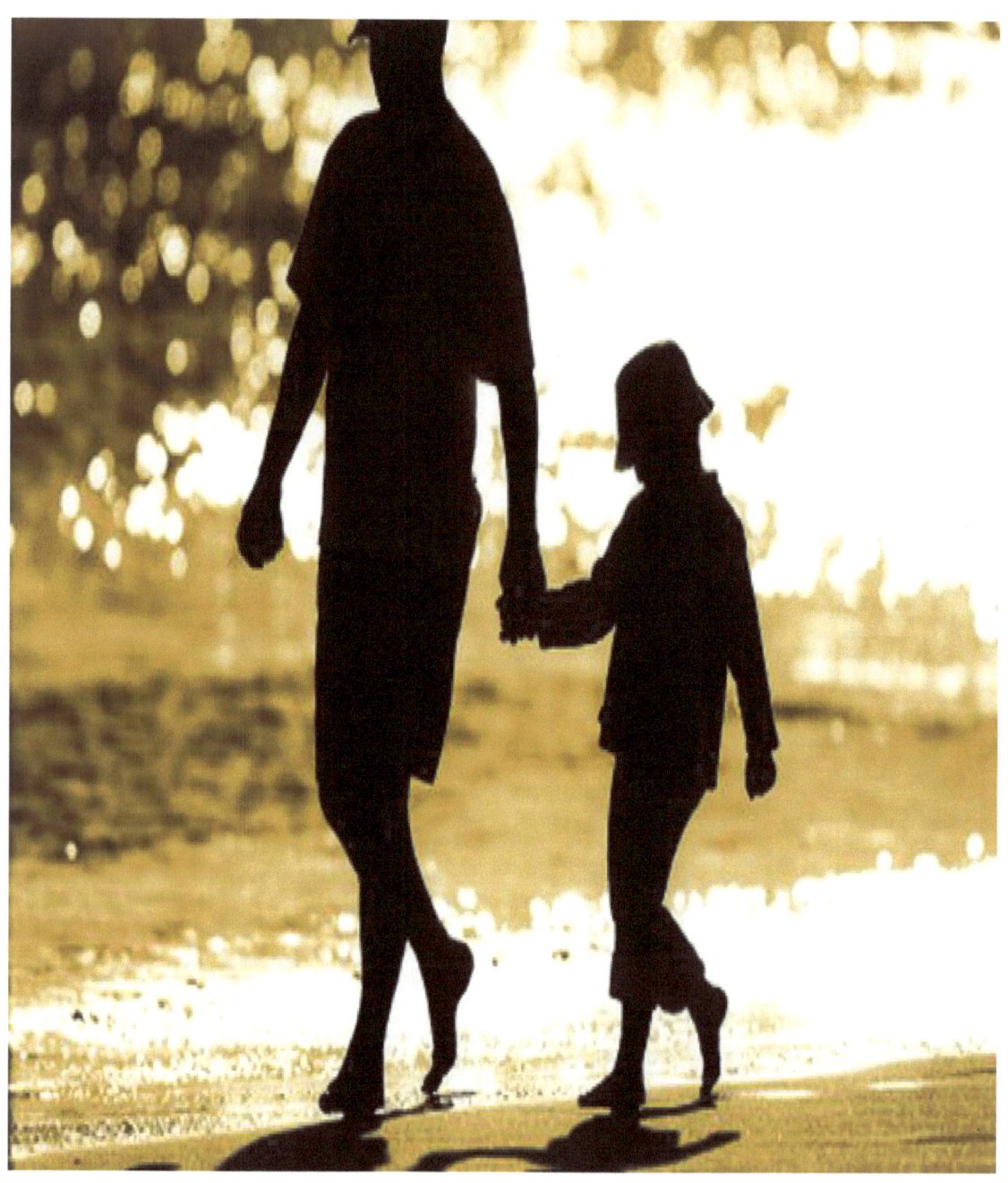

Dad thanks for being my support, my guide and my strength. Happy Father's Day!

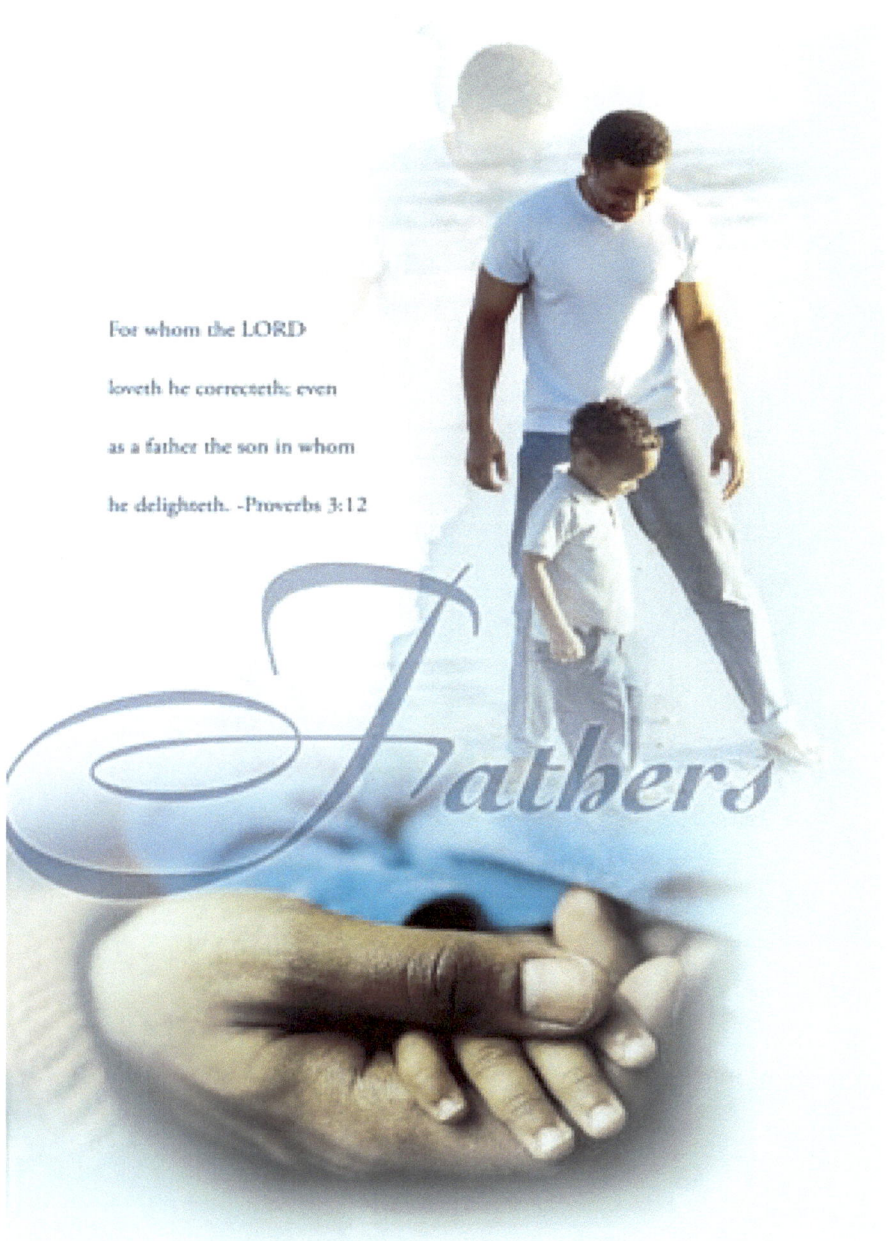

Fathers are very deciding. Happy Father's Day!

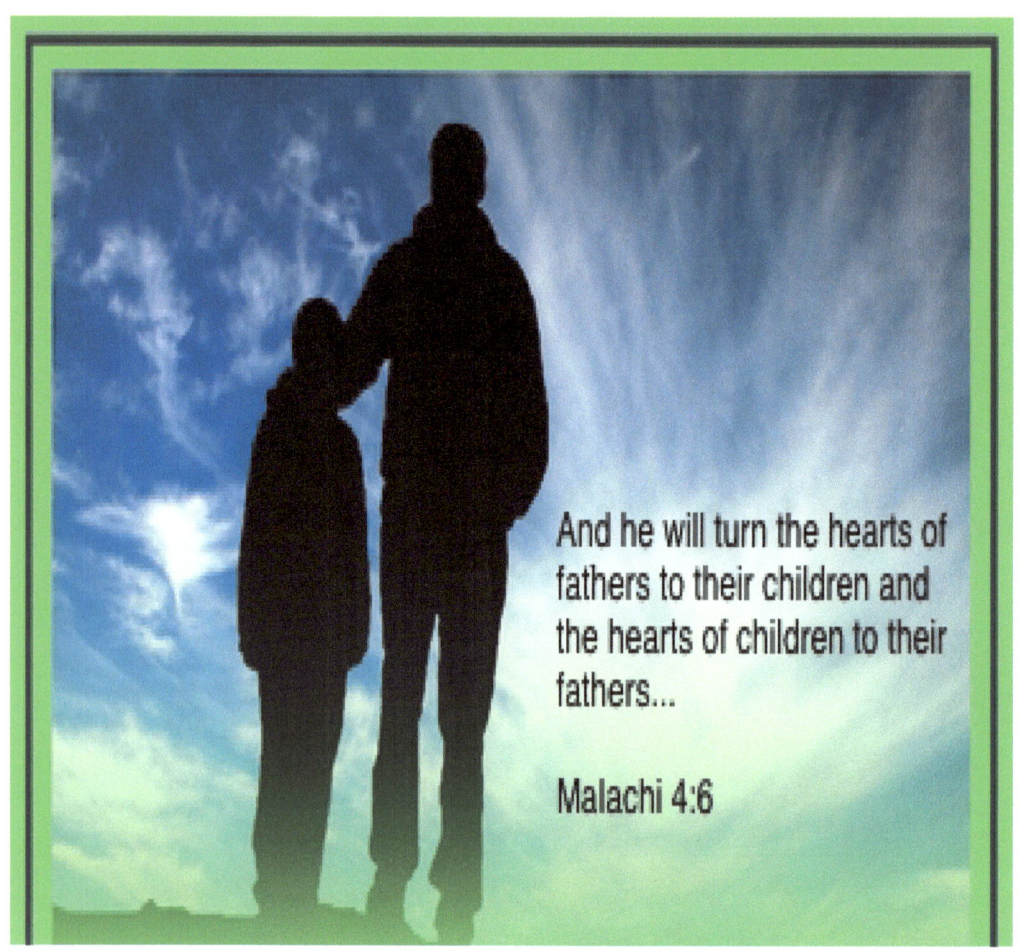

Fathers are someone to look up to no matter how tall we get.

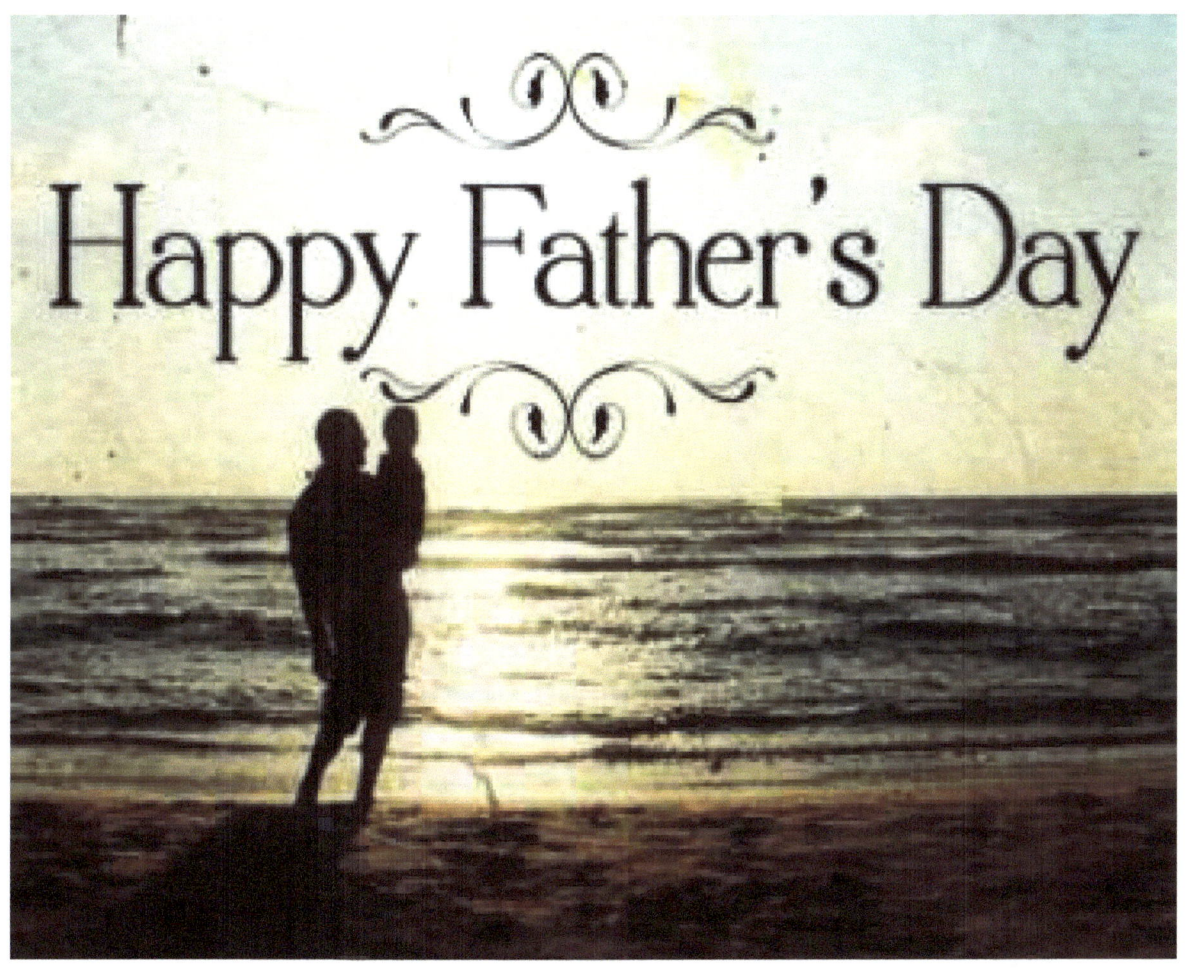

Fathers are funny and kind. Happy Father's Day

Fathers in jail and prison, I wish you all Happy Father's Day.

Fathers listen to your child or children. Happy Father's Day!

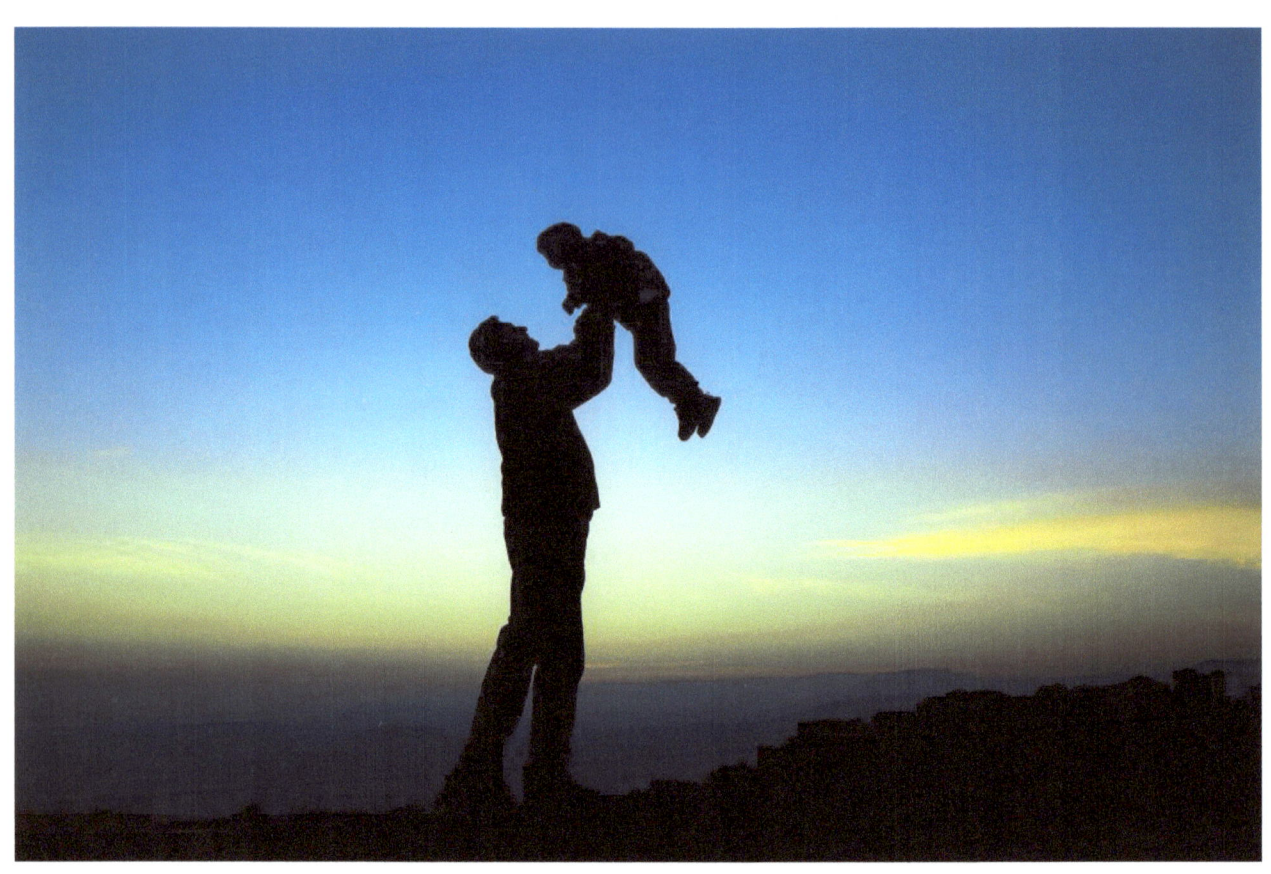

Fathers, in all that you do, your love plays a part in our life. Happy Father's Day!

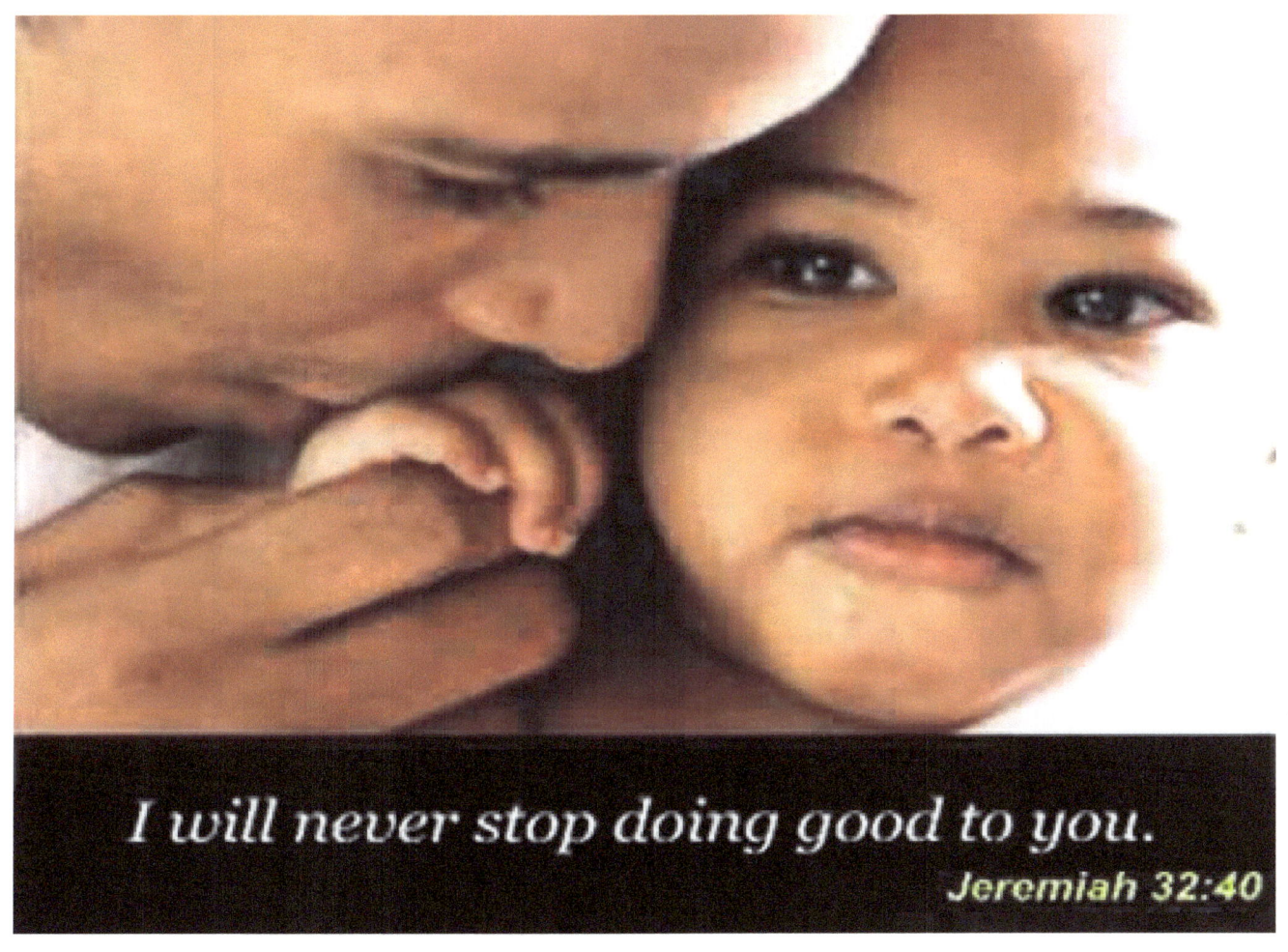

Fathers are magnanimous men. Happy Father's Day!

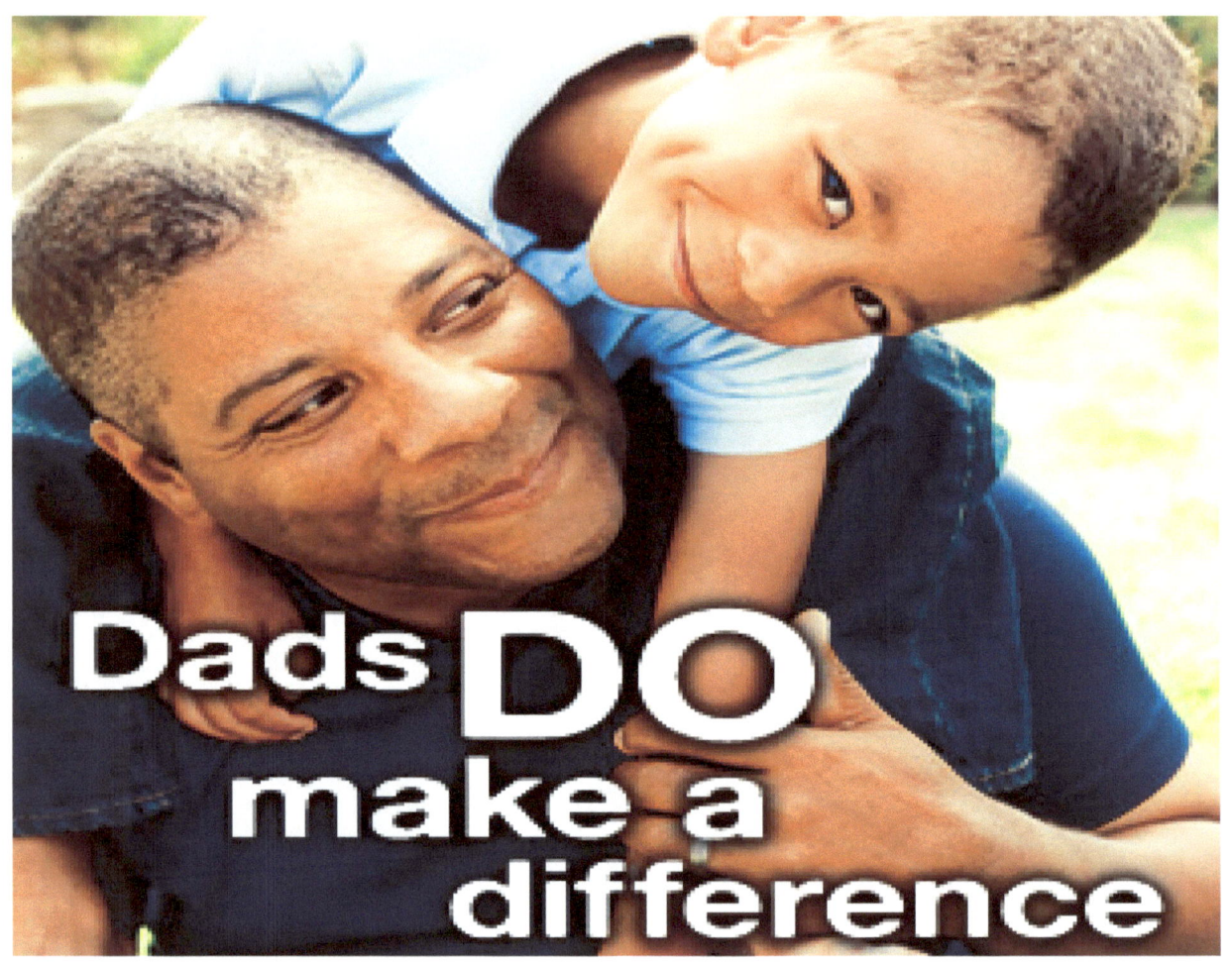

Happy Father's Day! Fathers are remarkable men.

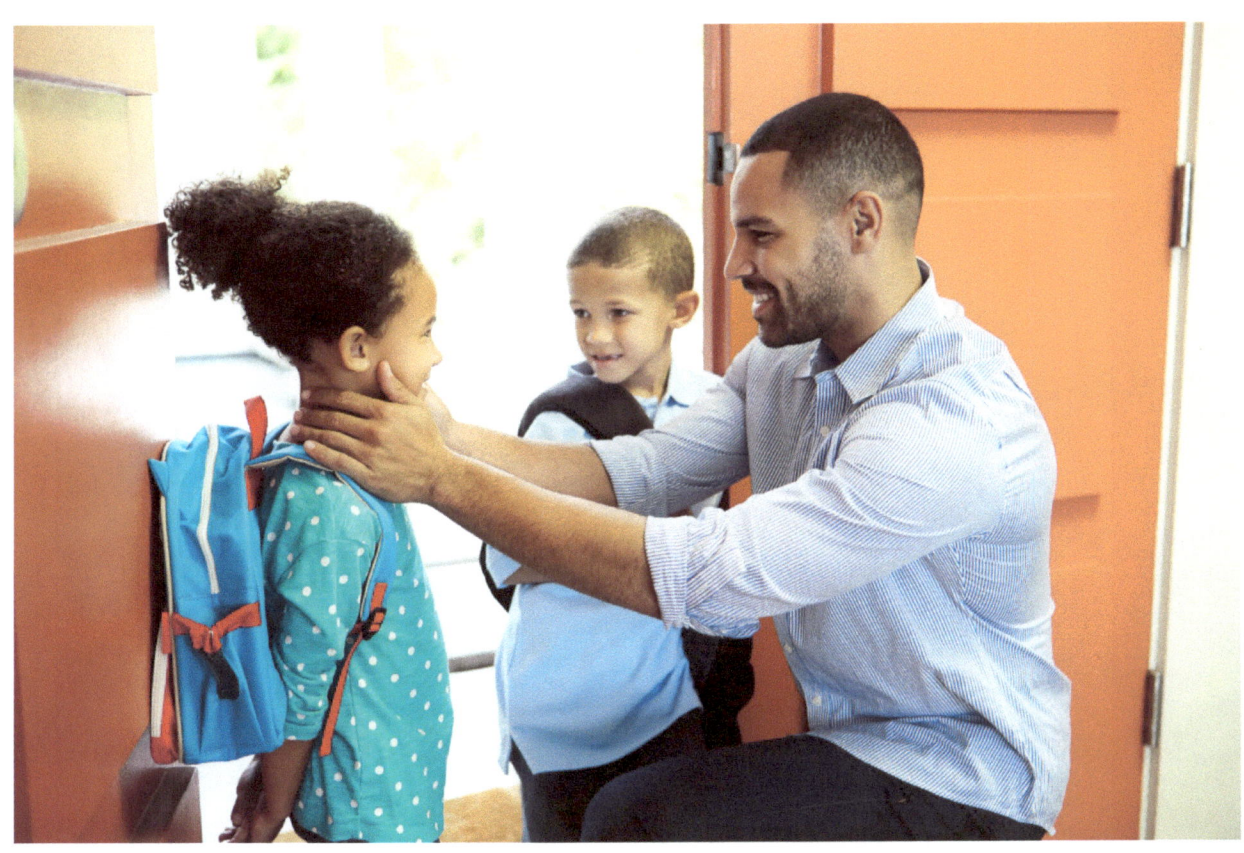

Happy Father's Day!

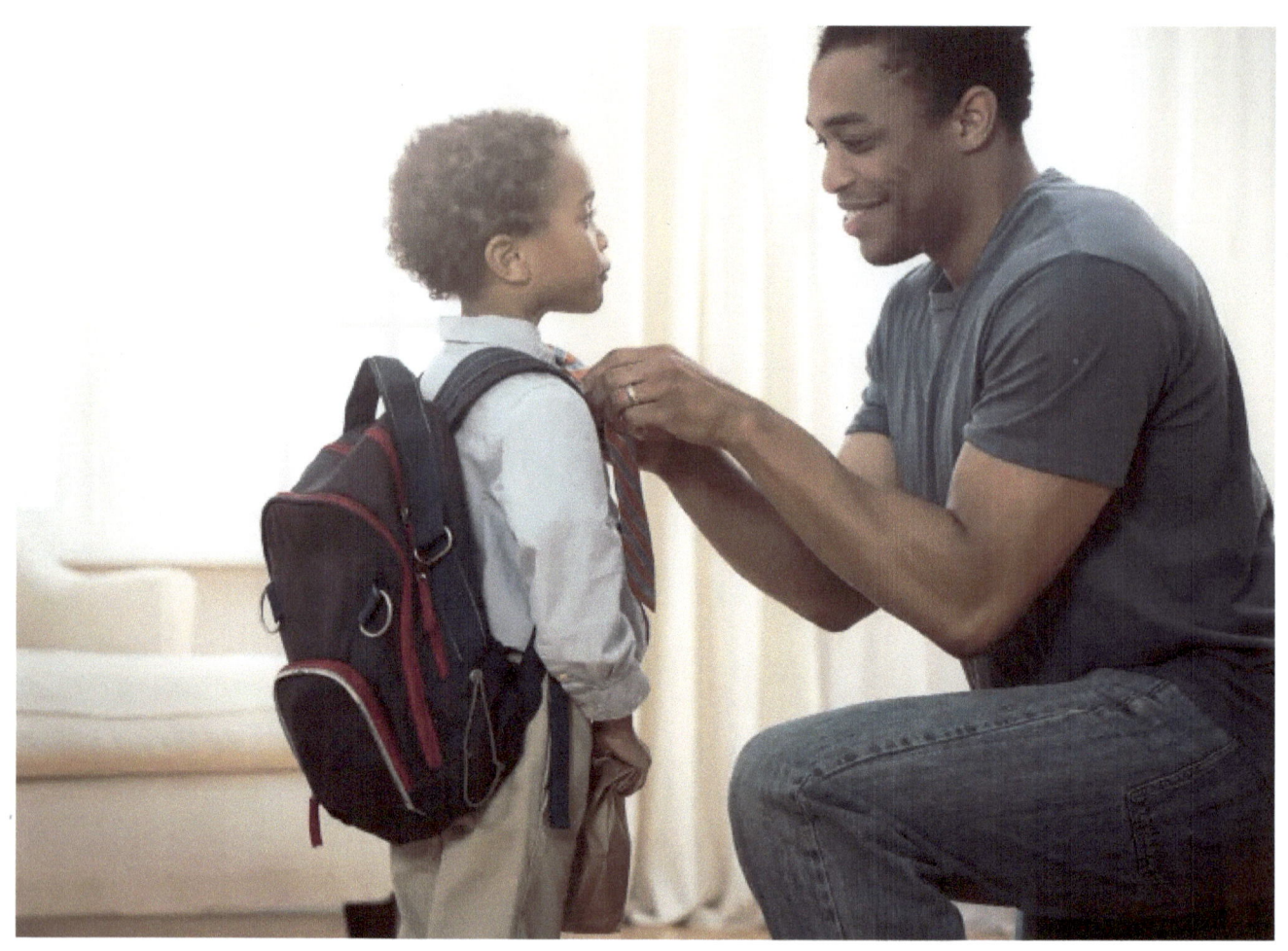

Happy Father's Day to all the teachers!

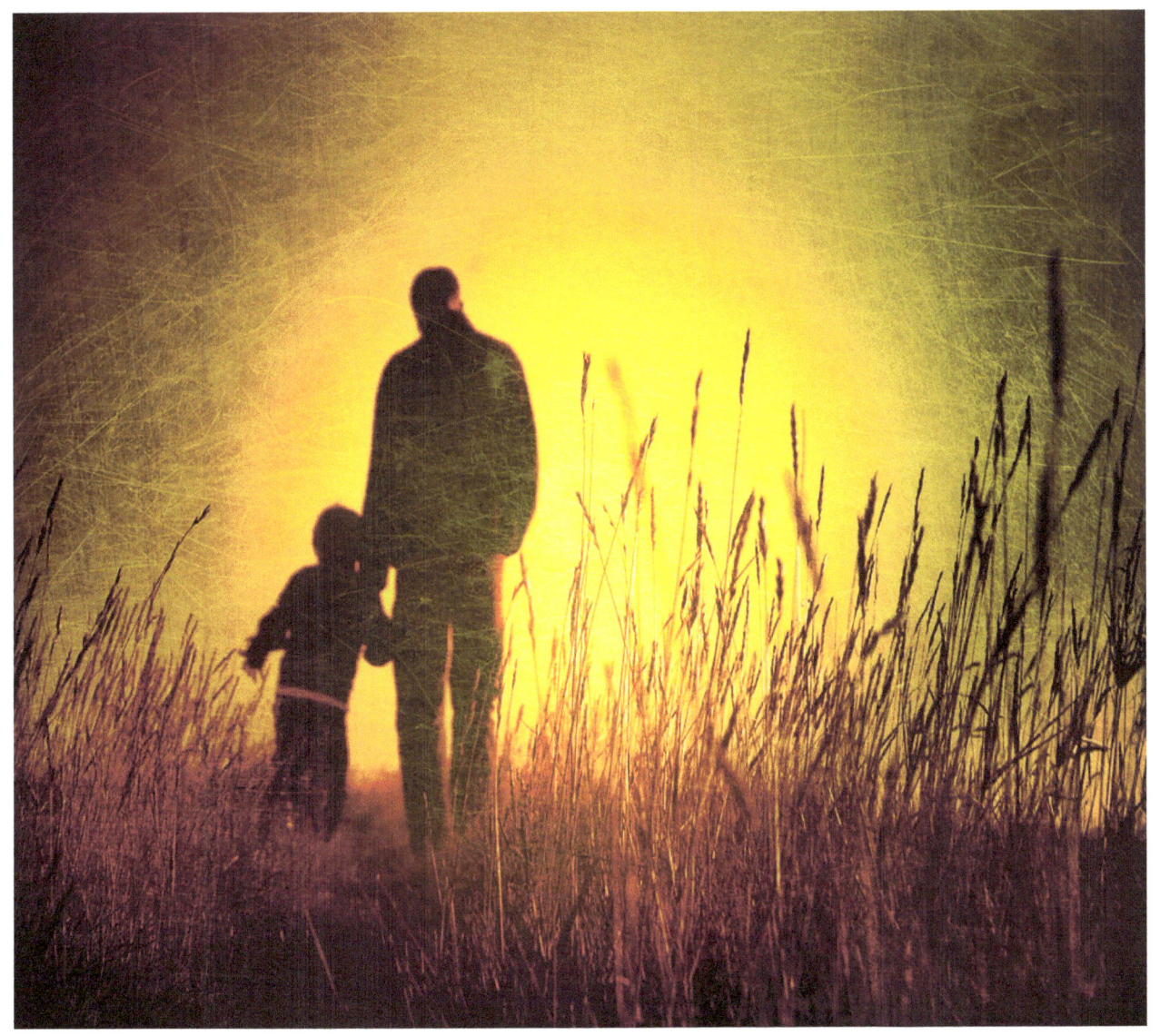

A father never wants to see his child go astray. Every day he tries his best to help them on their way.
Happy Father's Day!

Fathers, you're a king and we love you. Happy Father's Day!

Fathers, you taught us love and patience. Fathers you are the sunshine in our heart. Fathers, you have a heart of tenderness, a mind of wisdom. Happy Father's Day!

Go dad! Go dad! It's Father's Day! You're number 1! Don't forget! Not 2! Not 3! Not 4! Not 5! Not 6! Not 7! Not 8! Not 9! Not 10! Dad you're #1! Yes, dad you're #1! Go dad!

Happy Father's Day! God bless you all fathers. We honor you today and every day. Happy Father's Day! The best is yet to come...................